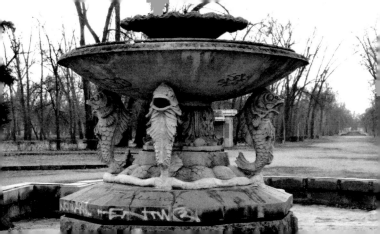

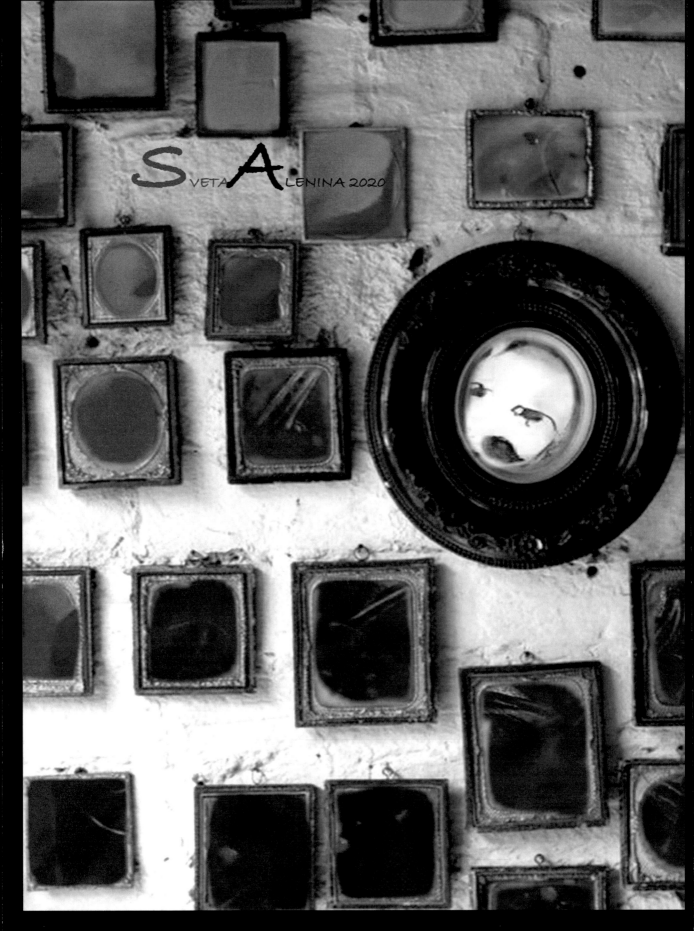

SVETA ALENINA 2020

Many are familiar with Jung's saying that
Depression is not always pathological. There is
time when the new page needs to be turned and a
new energy to be gathered in total rest. And I
think, that when nothing stops us from running
around and it's time for the new project, page,
mode one is forced to sit still. Often, Jung says,
that we get really sick or some accident happens
when it's the case.
Same is true for the collective, for the countries
and apparently even the whole Globe.

First of all:

WE ARE CONSCIOUSNESS - NOT
OUR BODIES. NOT JUST OUR
BODIES.

sveta alenina 2020

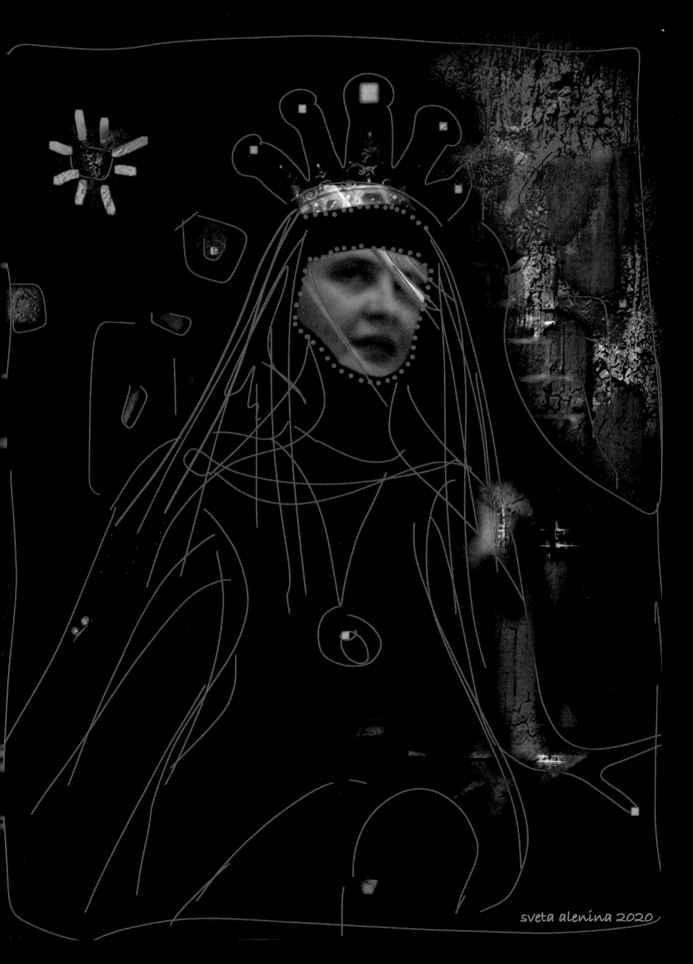

sveta alenina 2020

Sveta A. 2020

Let me sing you la-la-buy,
While you cry.
la-la-buying while you crying.

As I am walking primordially naked,
Empty Heaven is freezing my Soul,
Not important, forgotten my symbol,
I don't bother no one anymore.
Sunday day when I stop loving men, They
don't listen to me,
They can't hear,
That the truth is I never been human,
And could never love man as one.

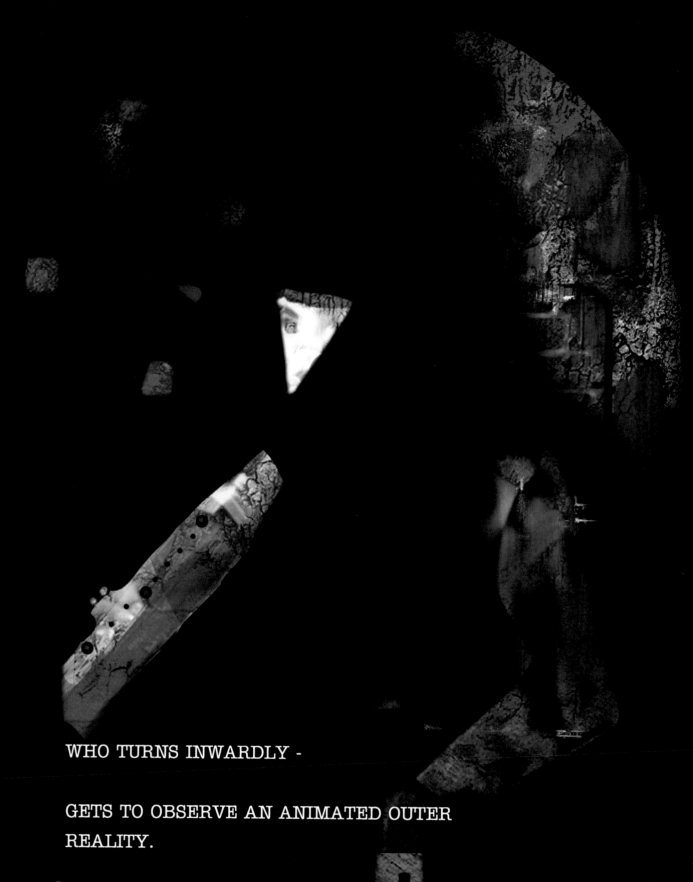

WHO TURNS INWARDLY -

GETS TO OBSERVE AN ANIMATED OUTER
REALITY.

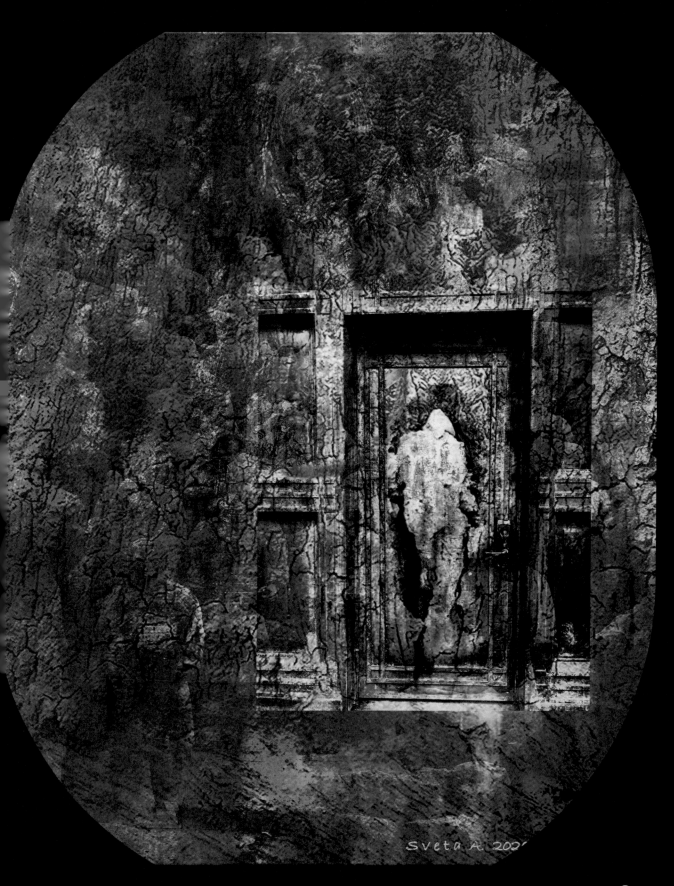

Sveta A. 202

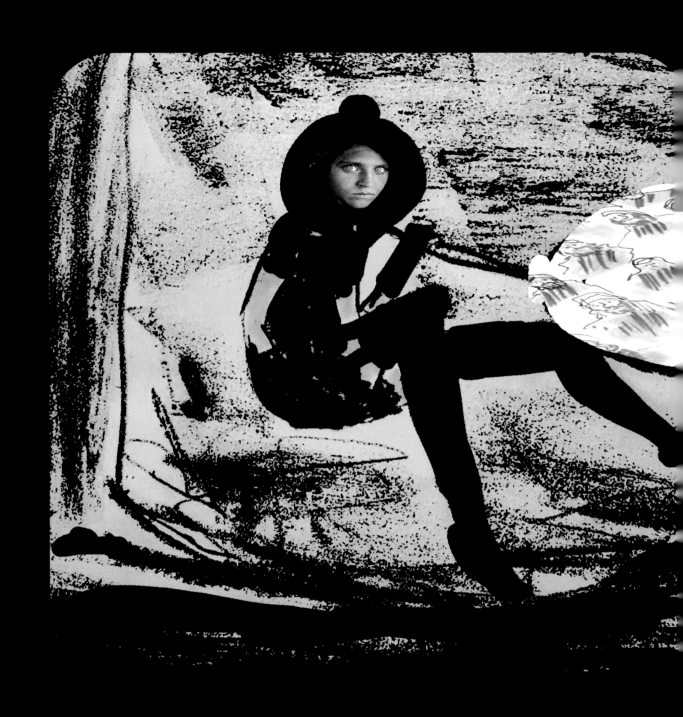

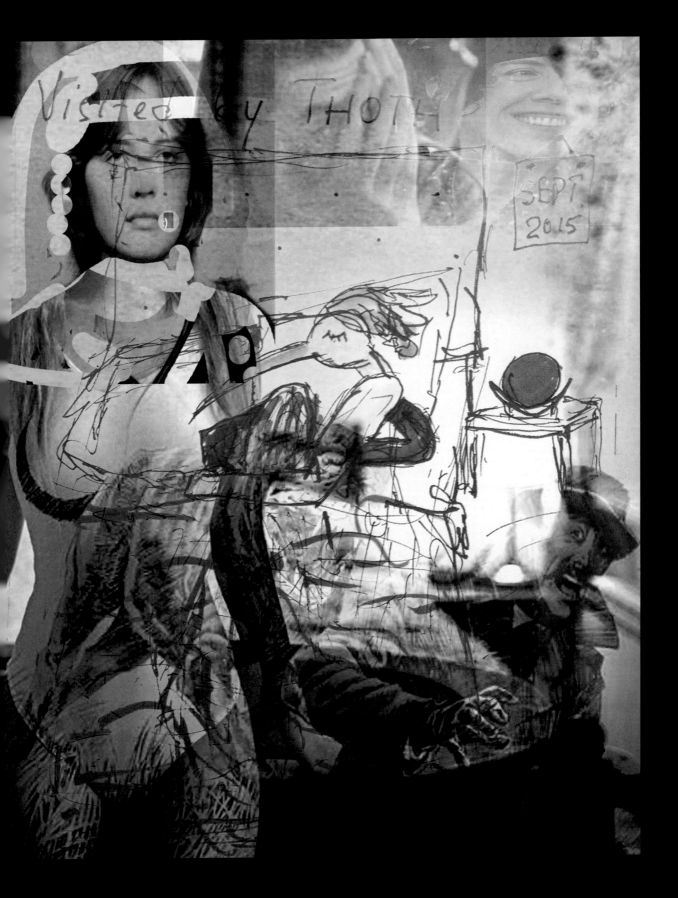

11

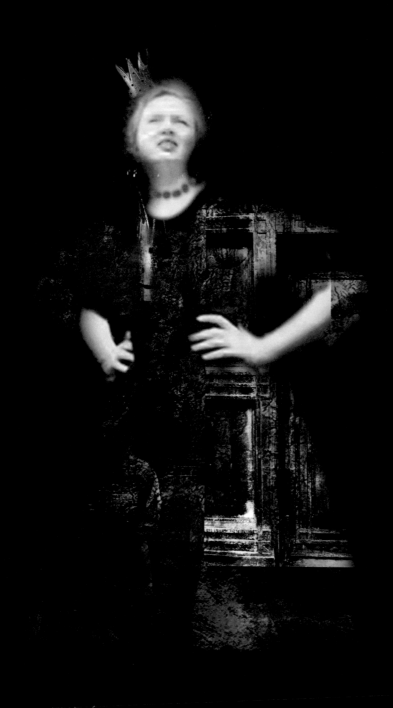

sveta alenina 2020

Your beautiful,
Stunning,
Hysterical laugh provoking....
... ways,
Make me suffocate!
In split moment of awe,
Everyone on the Globe,
Got aback and said: "Oh?"
Not a word,
Not a warning!
Not a breeze!
Not a shrug!
You just had enough!
Oh Vah!
Vah! Vah!

REAWAKENING RHYTHM TO REVERSE DISASTER

The tensions inside a primitive group are never greater than those involved in the struggle for existence of the group as a whole. Were it otherwise, the group would speedily perish

Fear of enemies and of hunger predominates even over sexuality, which is, as we know, no problem at all for the primitive, as it is far simpler to get a woman than it is to get food...

Confronted with disaster, one is obliged to ask oneself how it is to be remedied. The libido that is forced into regression by the obstacle always reverts to the possibilities lying dormant in the individual. A dog, finding the door shut, scratches at it until it is opened, and a man unable to find the answer to a problem rubs his nose, pulls his lower lip, scratches his ear, and so on

If he gets impatient, all sorts of other rhythms appear; he starts drumming with his fingers, shuffles his feet about, and it will not be long before certain distinctly sexual analogies manifest themselves, such as masturbation gestures...

Now when the libido is forced back by an obstacle, it does not necessarily regress to earlier sexual modes of application, but rather to the rhythmic activities of infancy which serve as a model both for the act of nutrition and for the sexual act itself. The material before us does not seem to preclude the possibility that the invention of fire-making came about in the manner suggested, that is, through the regressive reawakening of rhythm... Carl Jung. CW 5 para 217

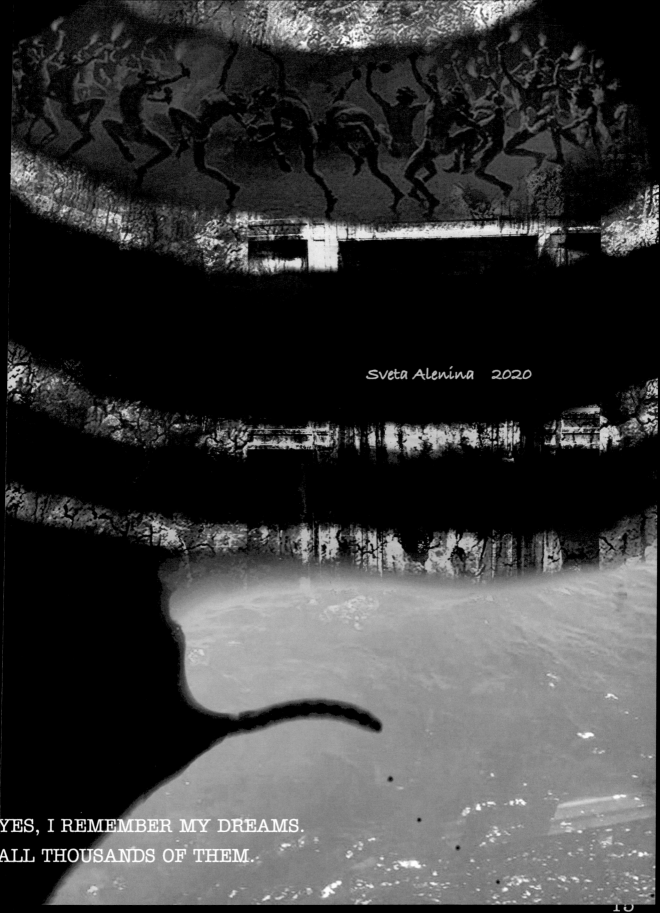

Sveta Alenina 2020

YES, I REMEMBER MY DREAMS.
ALL THOUSANDS OF THEM.

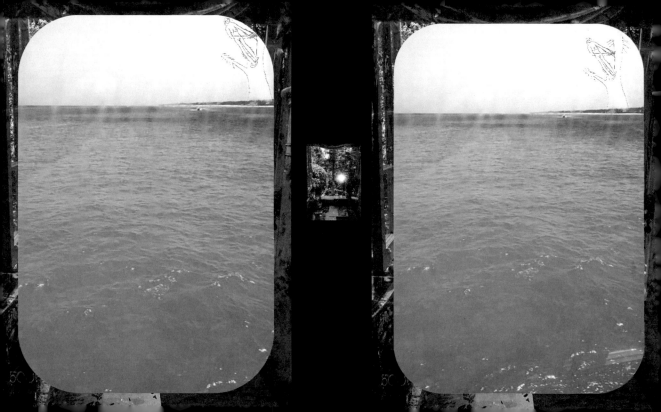

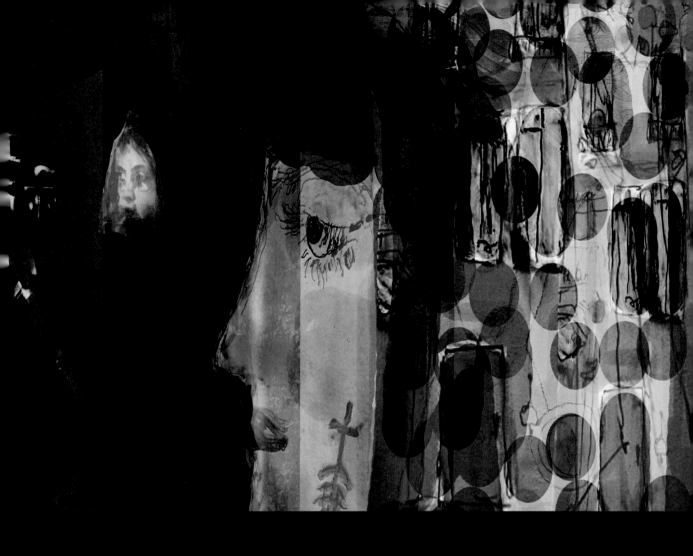

Unencumbered by the trivial.
Smoking weed,
Life is striding through the field.

Poppy's field.

Simply thoughts were swimming by
Fishes...
Baba Yaga next to me...
Vicious.
Everything is absolutely the same:
Coffee, faces, mood, house.
I will not die today,
Not in this boring blouse.

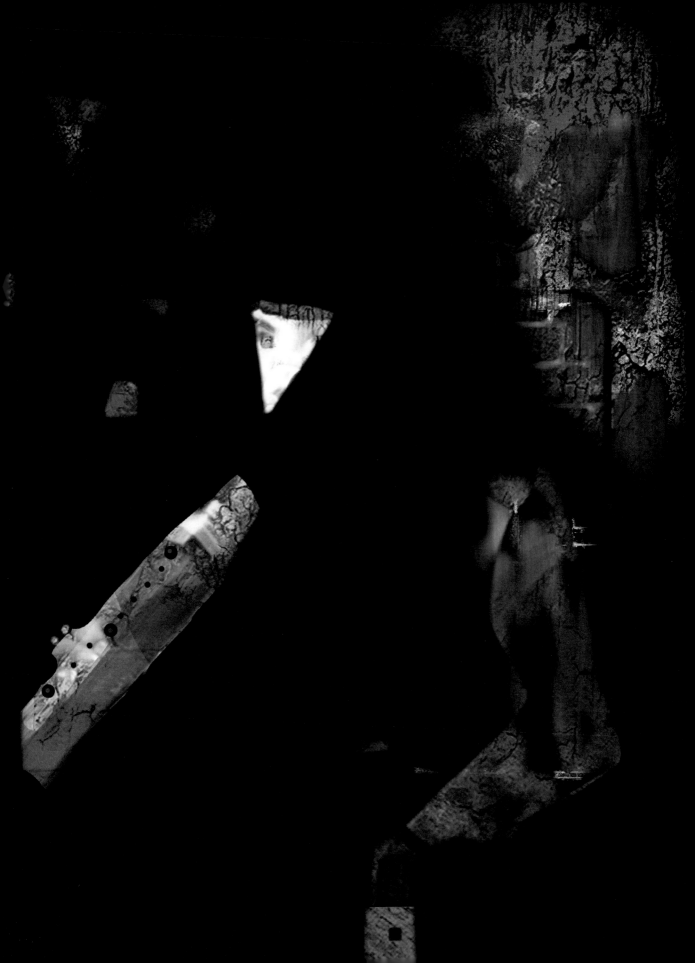

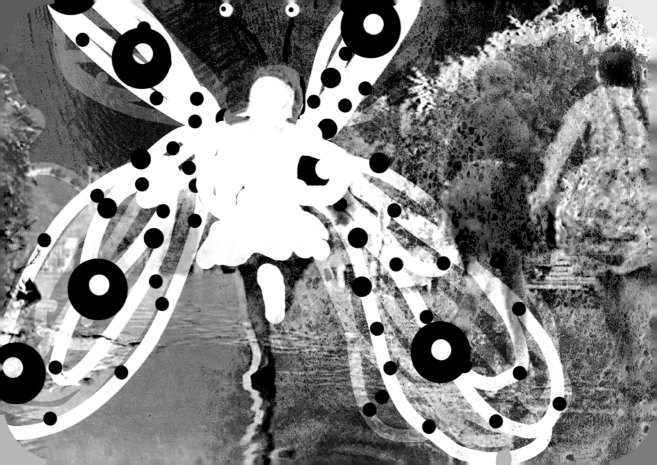

sveta alenina 2020

21

I mostly live in euphoria,
Deserved or not,
And in a middle of terror and
death
She stands by me in Grey with
little roses patterned dress.

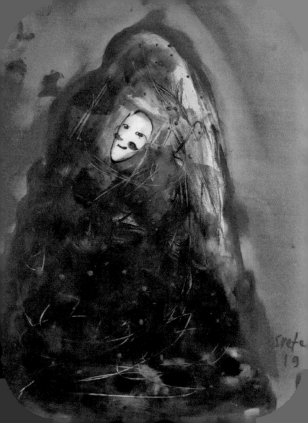

Lightning Source UK Ltd.
Milton Keynes UK
UKRC022315300520
364138UK00013B/135